DEVOTIONAL COLORING

Visual Scriptures

A MEDITATIVE COLORING BOOK

A Note from the Illustrator:

As I created the first few illustrations for this book, I considered adding a little signature to personalize it. I quickly realized the image of the cross symbolizes the purpose for these books; without the cross we have nothing. I've been incredibly blessed in my life and the opportunity to create visual scriptures has been a wonderful way to give the glory back to God. I hope you enjoy finding the small cross I incorporated into each illustration. To me, it's a literal example of "seek and ye shall find." If we look for the good, the joyful, and the happiness available to us through the grace of Christ, we will find it.

—*Pam*

So then faith comes by hearing and hearing by the word of God.
Romans 10:17

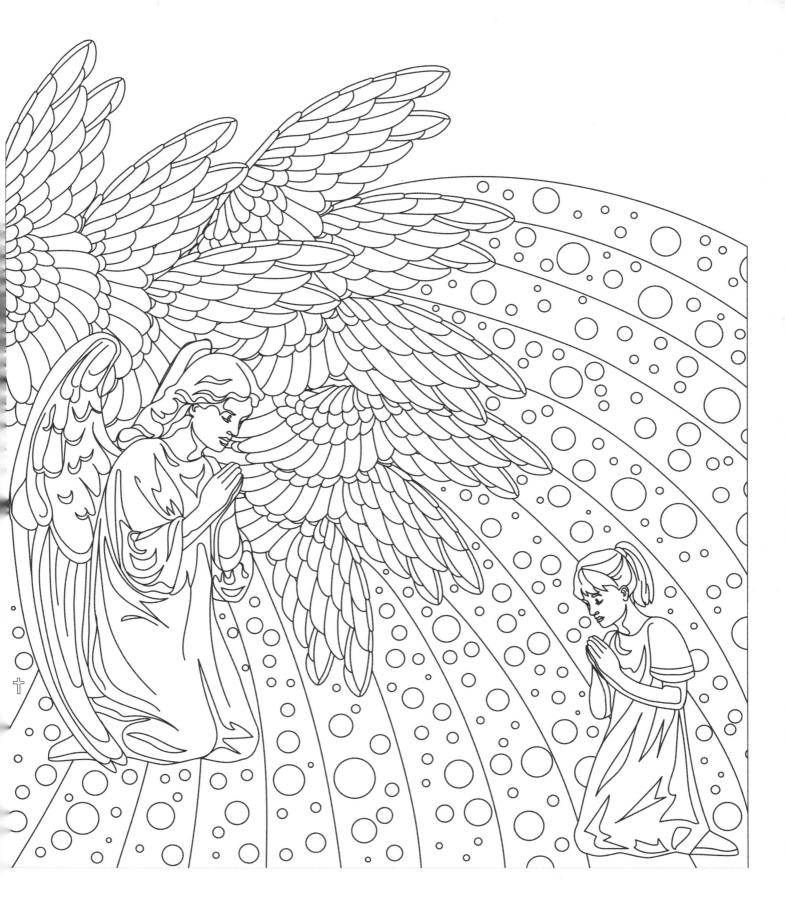

Likewise, I say unto you, there is joy in the presence of the angels of God over one sinner that repenteth.

Luke 15:10

Thy word have I hid in mine heart, that I might not sin against thee.
Psalms 119:11

But they that wait upon the LORD shall renew their strength; they shall mount up with wings as eagles; they shall run, and not be weary; and they shall walk, and not faint.

Isaiah 40:31

It is of the LORD's mercies that we are not consumed, because his compassions fail not.
They are new every morning: great is thy faithfulness.
Lamentations 3:22-23

Delight thyself also in the LORD: and he shall give thee the desires of thine heart.
Commit thy way unto the LORD; trust also in him; and he shall bring it to pass.

Psalms 37:4-5

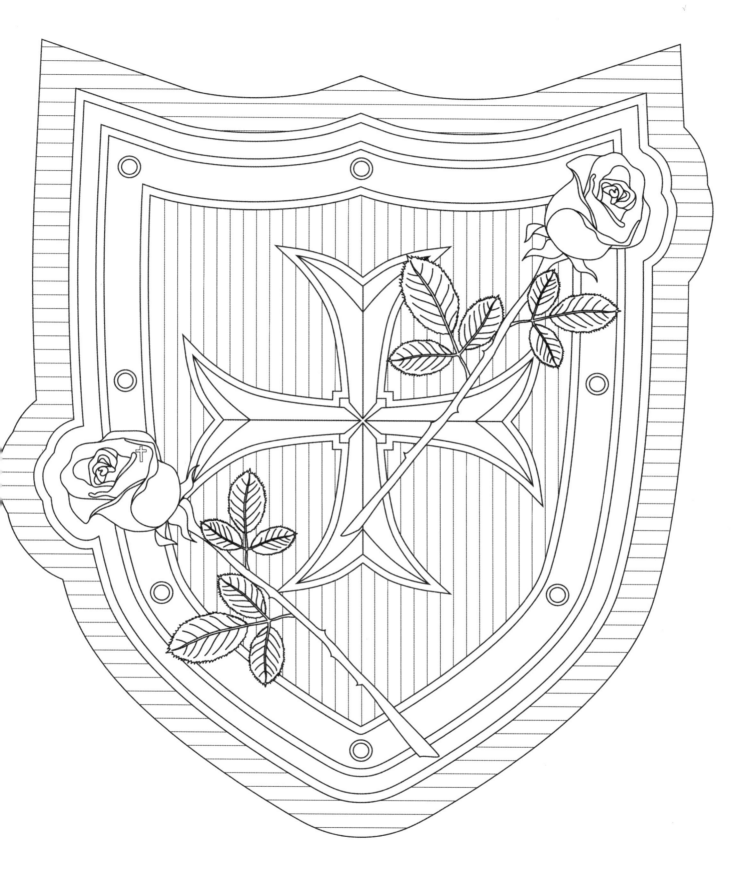

The LORD shall fight for you, and ye shall hold your peace.
Exodus 14:14

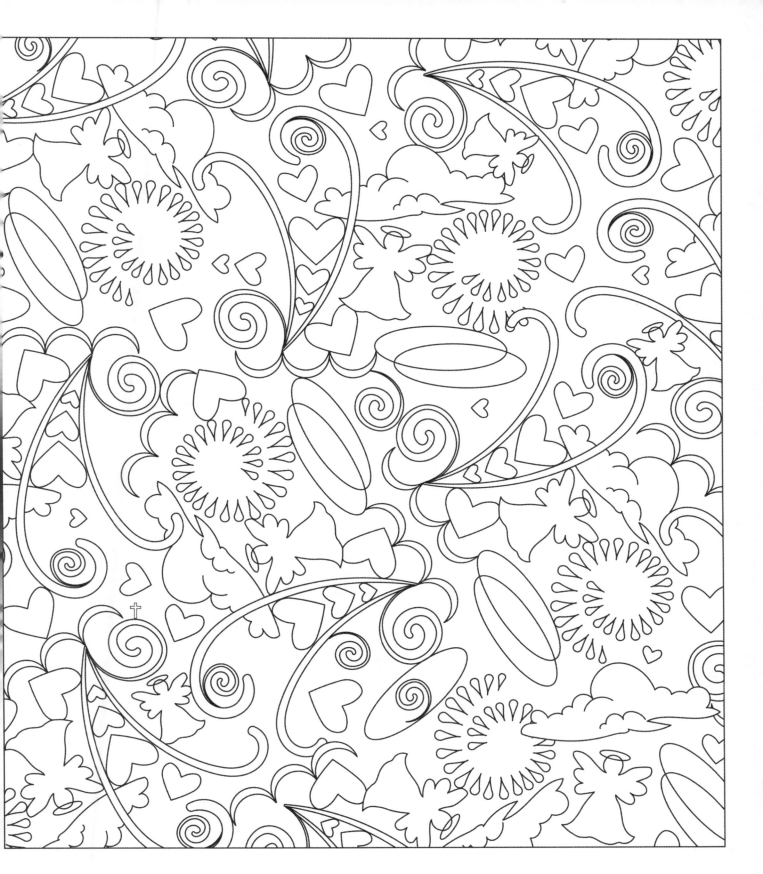

...neither death, nor life, nor angels, nor principalities, nor powers, nor things present, nor things to come, Nor height, nor depth, nor any other creature, shall be able to separate us from the love of God which is in Christ Jesus our Lord.
Romans 8:38-39

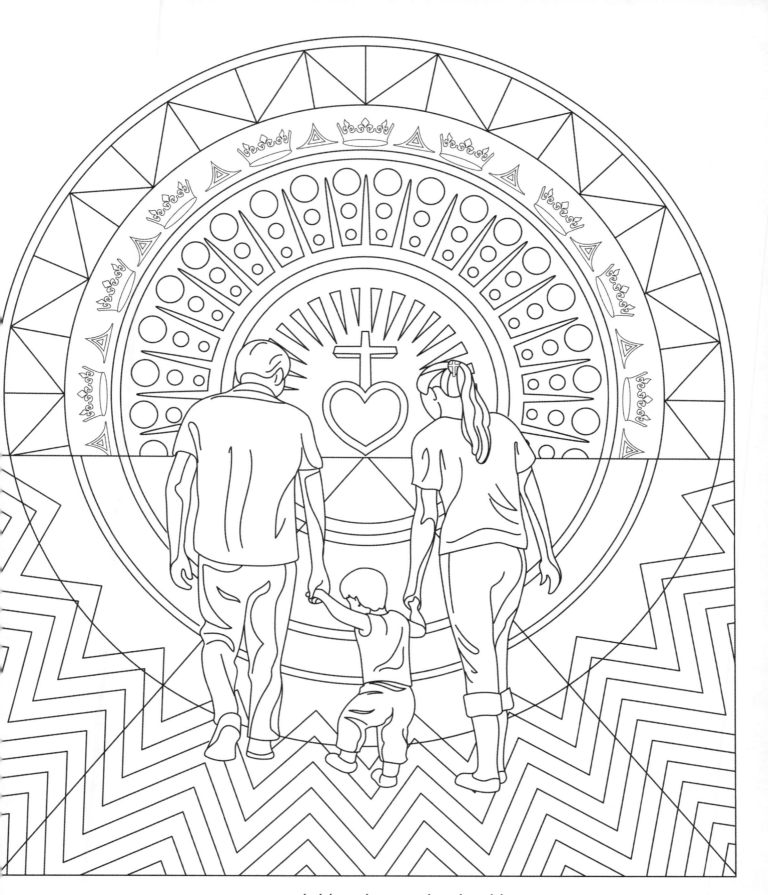

Train up a child in the way he should go,
and when he is old he will not depart from it.

Proverbs 22:6

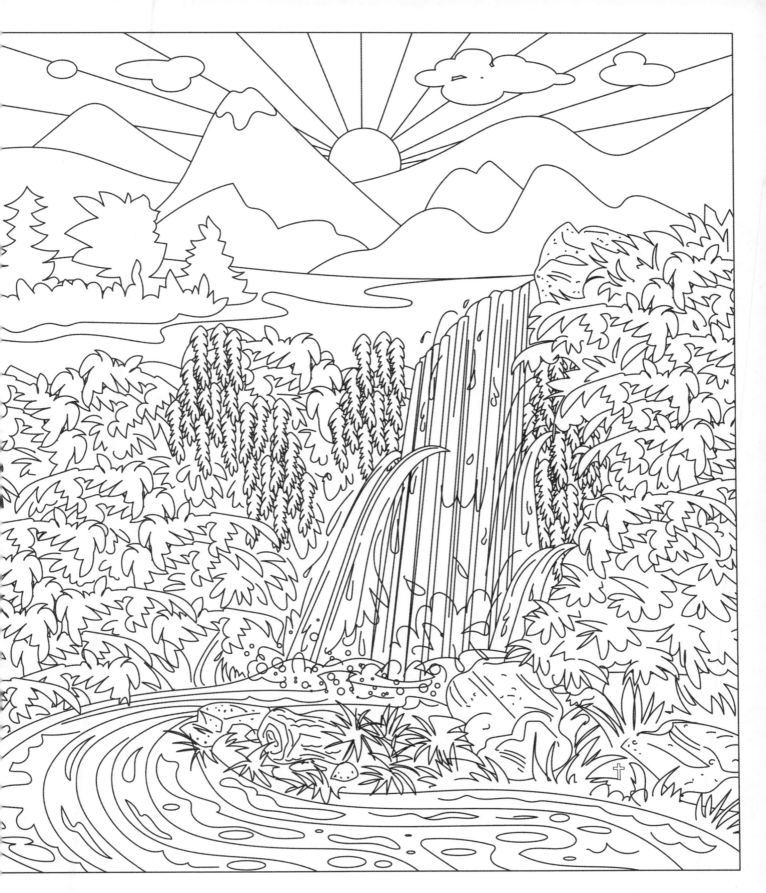

For the LORD thy God bringeth thee into a good land, a land of brooks of water, of fountains and depths that spring out of valleys and hills;

Deuteronomy 8:7

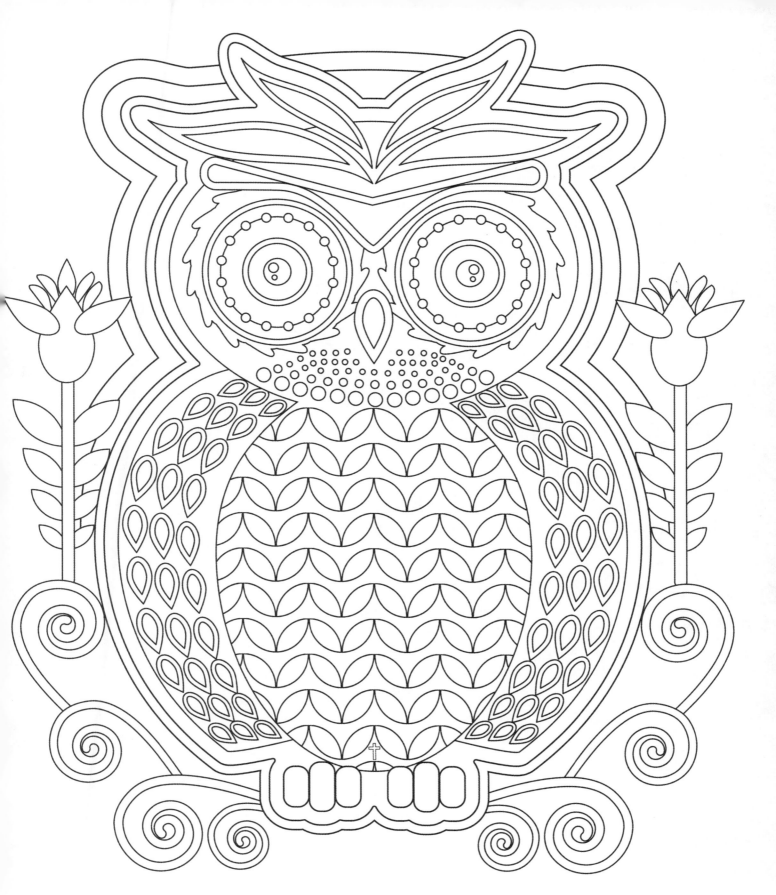

Be not wise in thine own eyes, fear the Lord and depart from evil.

Proverbs 3:7

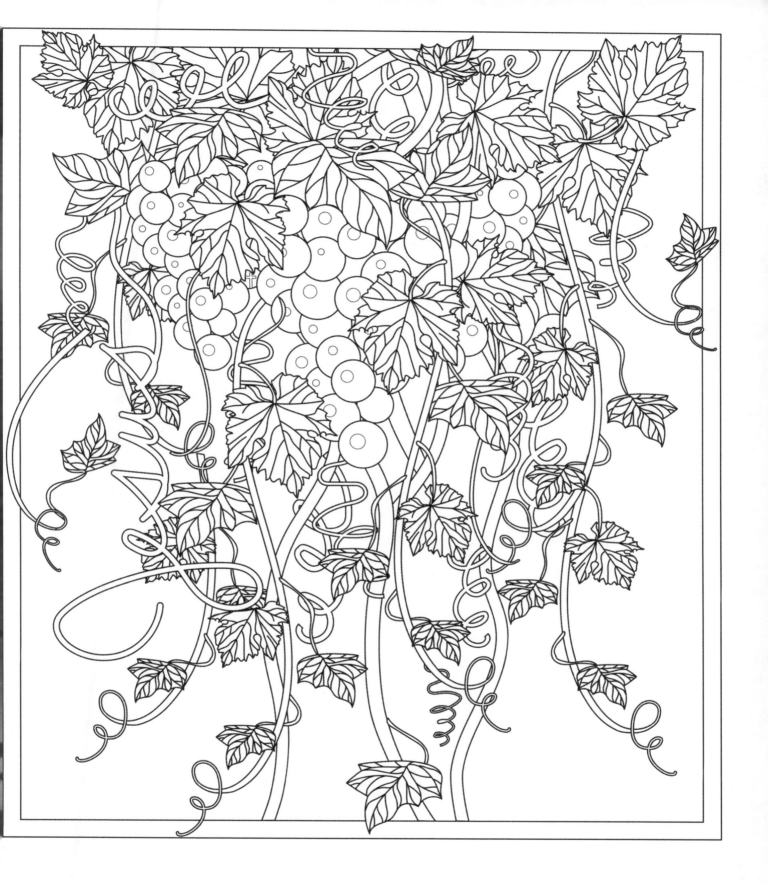

I am the vine, ye are the branches: He that abideth in me, and I in him,
the same bringeth forth much fruit: for without me ye can do nothing.

John 15:5

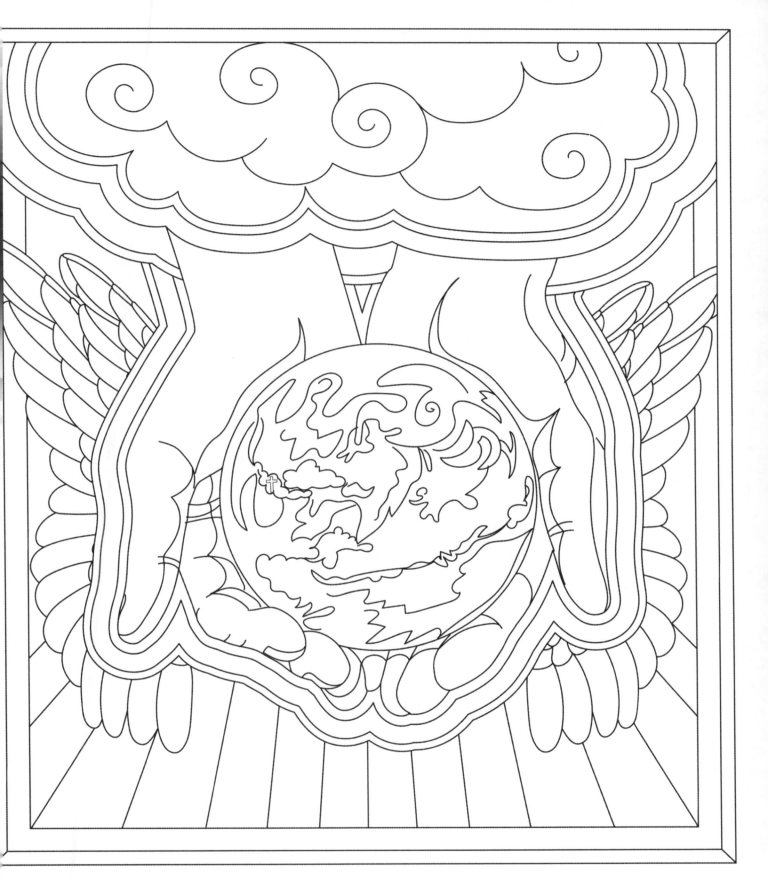

...I am the Lord which exercise lovingkindness, judgment, and righteousnesss, in the earth: for in these things I delight, saith the Lord.
Jeremiah 9:24

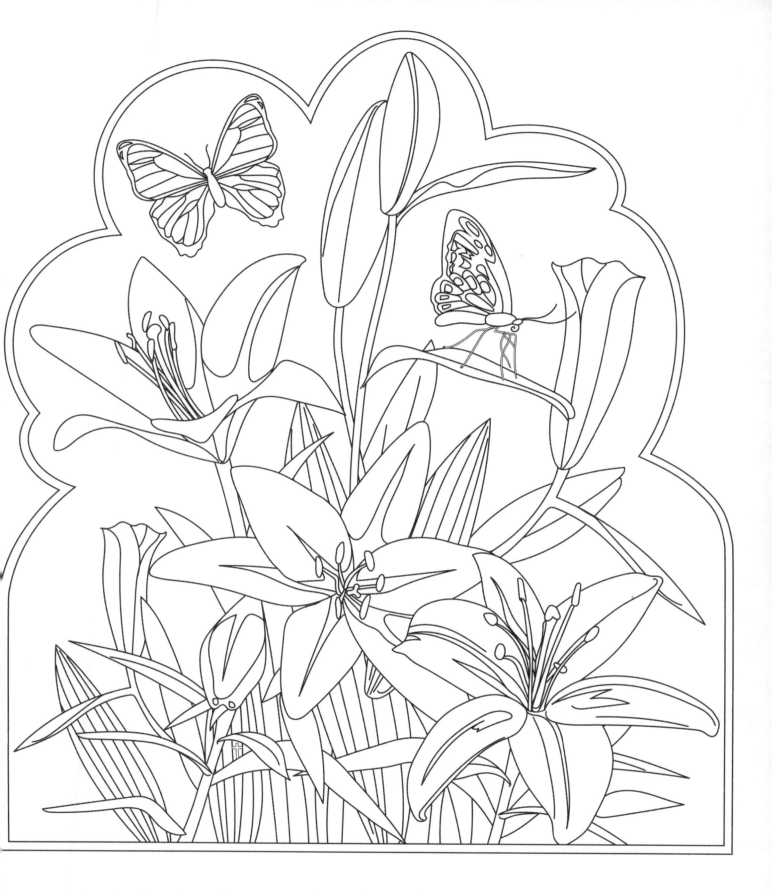

Consider the lilies how they grow: they toil not, they spin not; and yet I say unto you, that Solomon in all his glory was not arrayed like one of these.
Luke 12:27

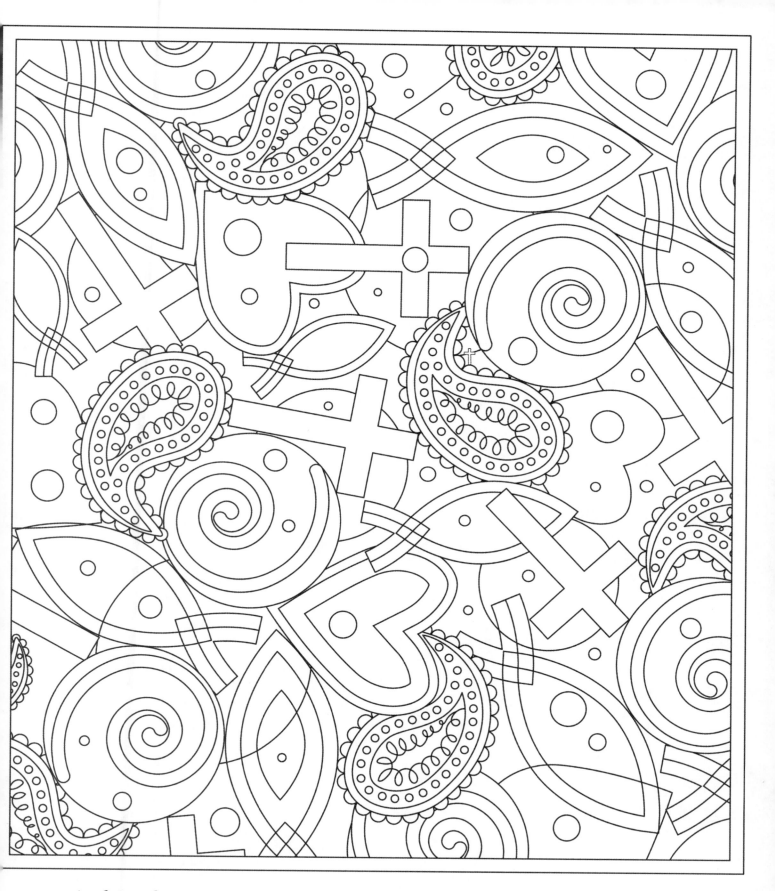

But the fruit of the Spirit is love, joy, peace, longsuffering, gentleness, goodness, faith.
Galatians 5:22

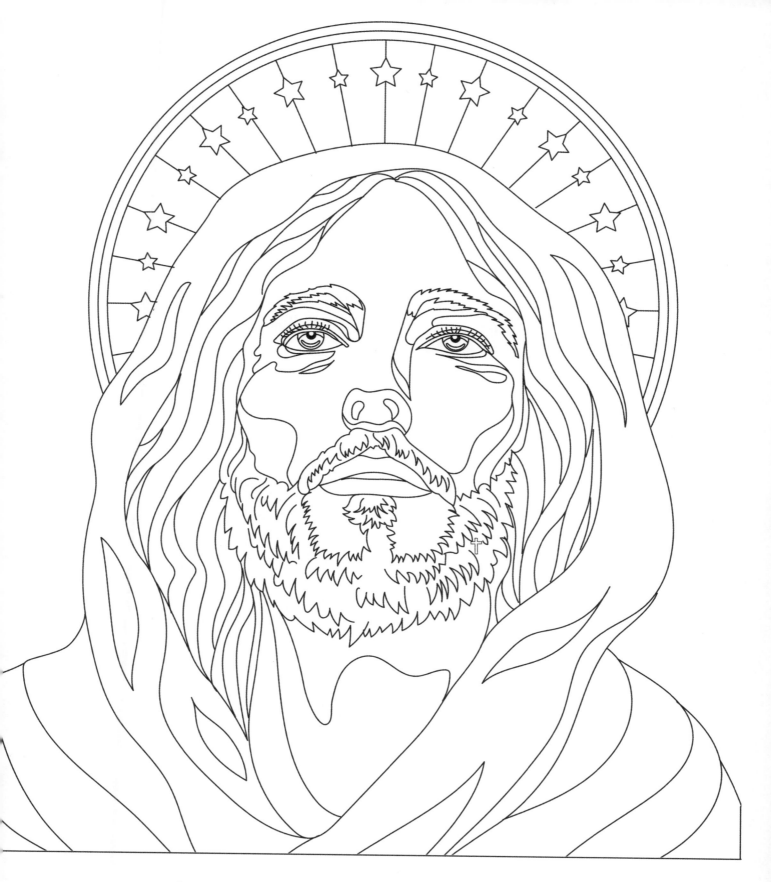

Seek the Lord, and his strength: seek his face evermore.

Psalms 105:4

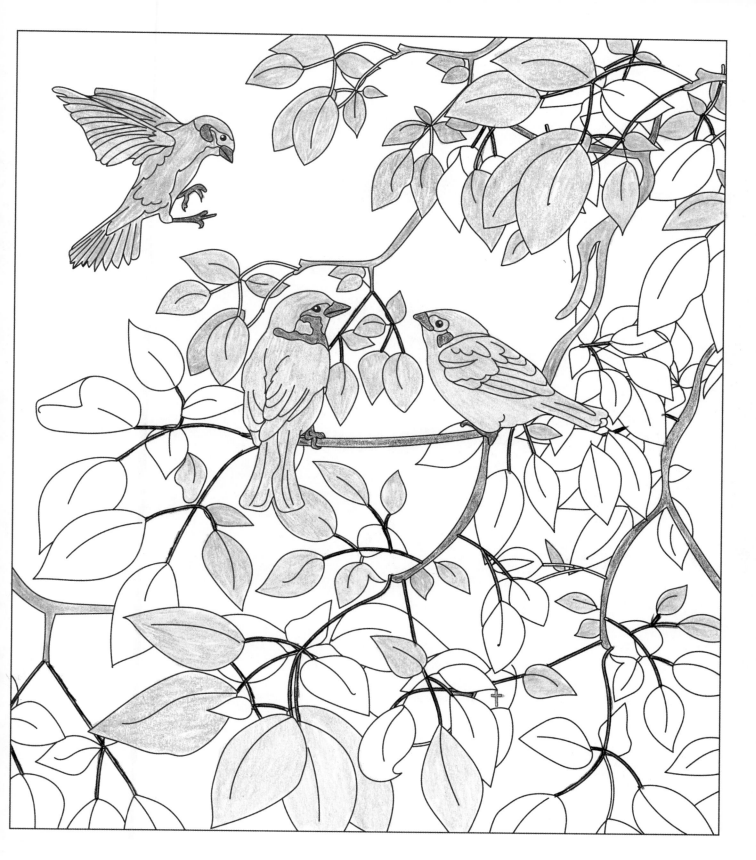

*Are not two sparrows sold for a farthing? and one of them shall not fall on the ground
without your Father. But the very hairs of your head are all numbered.
Fear ye not therefore, ye are of more value than many sparrows.*
Matthew 10:29-31

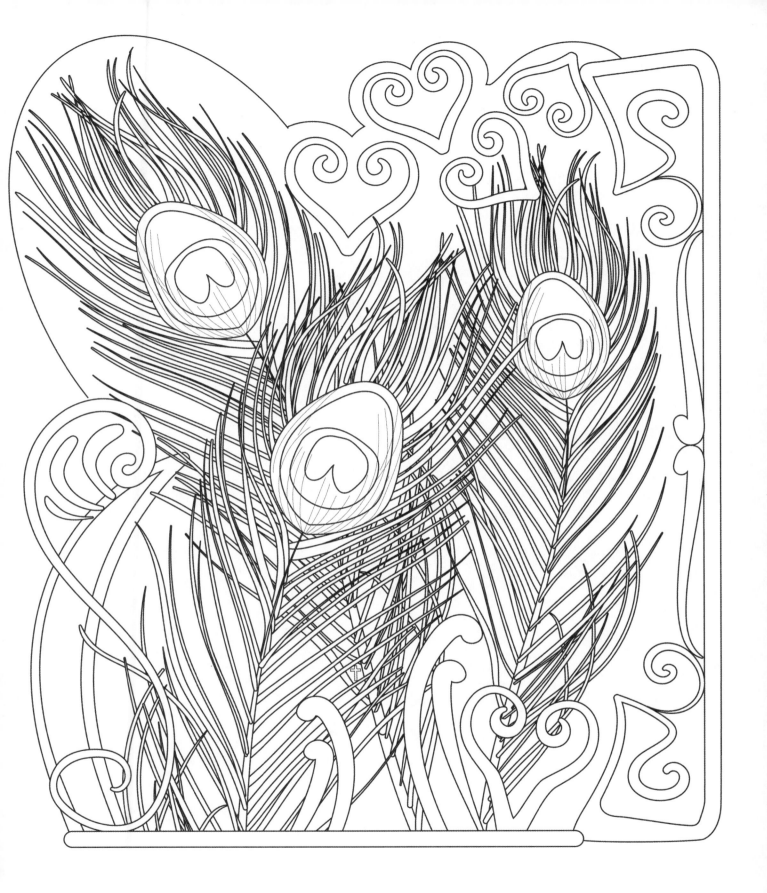

What shall we then say to these things?
If God be for us, who can be against us?
Romans 8:31

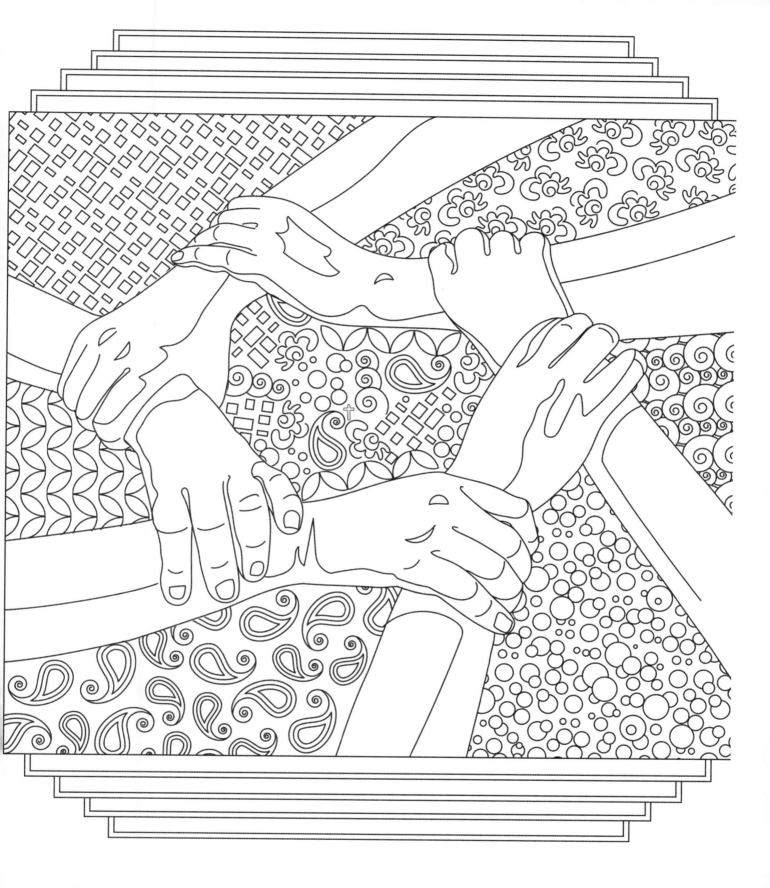

Behold, how good and how pleasant it is for brethren to dwell together in unity!

Psalms 133

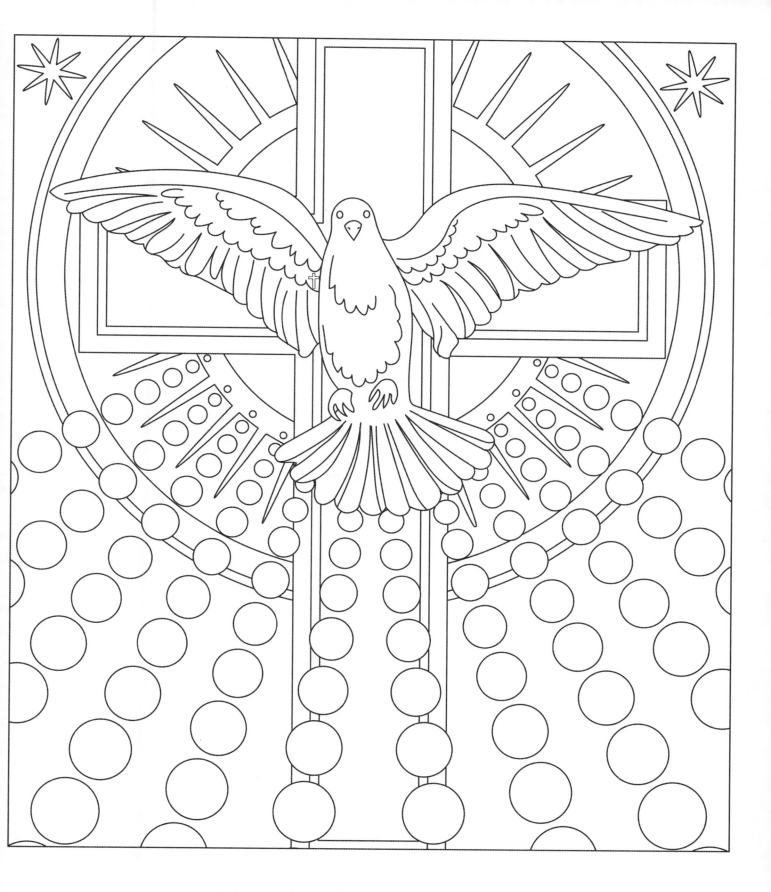

I can do all things through Christ which strengtheneth me.

Philippians 4:13

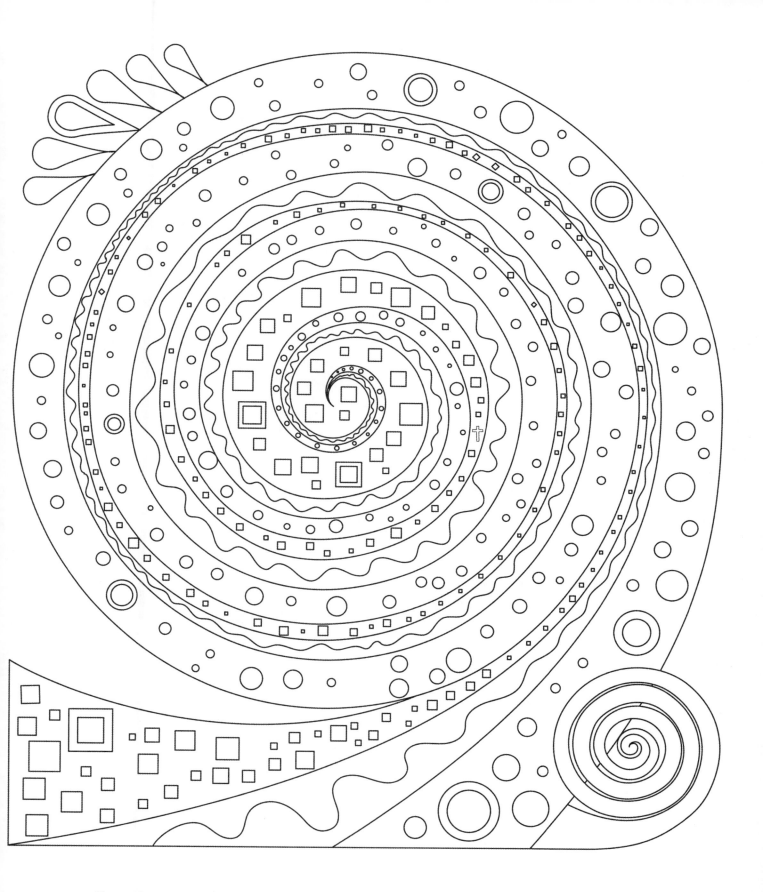

I will meditate in thy precepts, and have respect unto thy ways. I will delight myself in thy statutes: I will not forget thy word.

Psalms 199:15-16

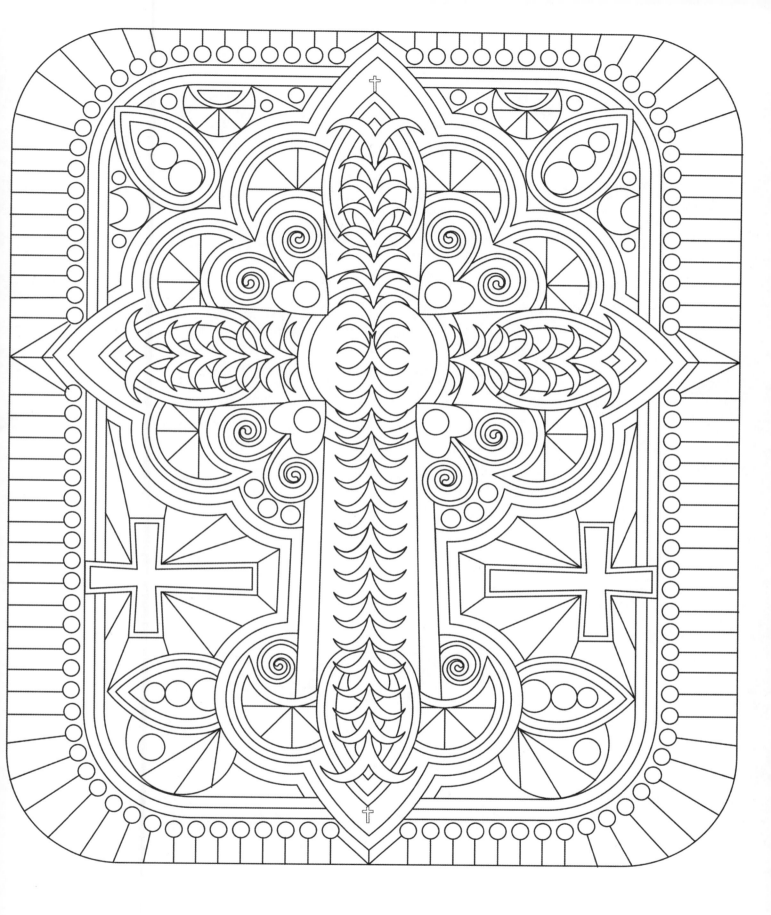

... take up the cross, and follow Me.
Mark 10:21

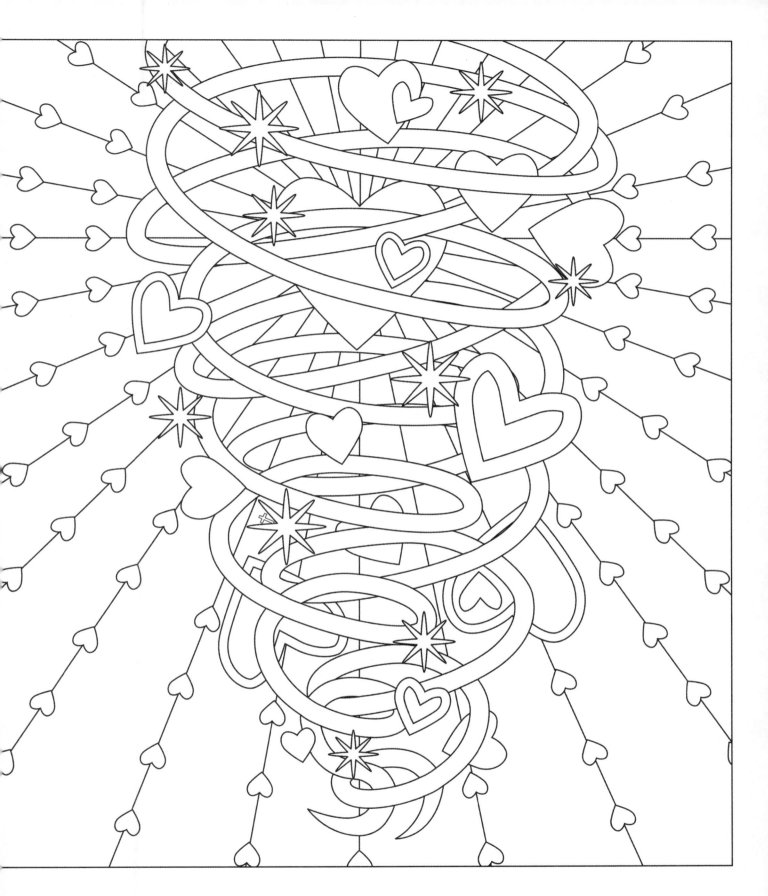

And we have known and believed the love that God hath to us. God is love;
and he that dwelleth in love dwelleth in God, and God in him.

1 John 4:16

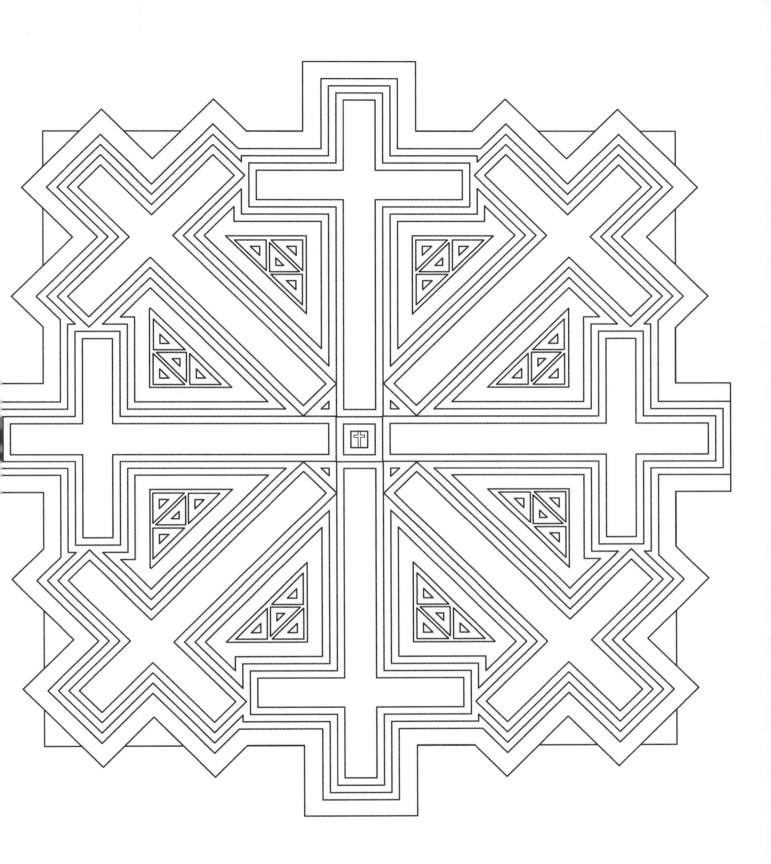

For his merciful kindness is great toward us: and the truth of the LORD
endureth for ever. Praise ye the LORD.

Psalms 117:2

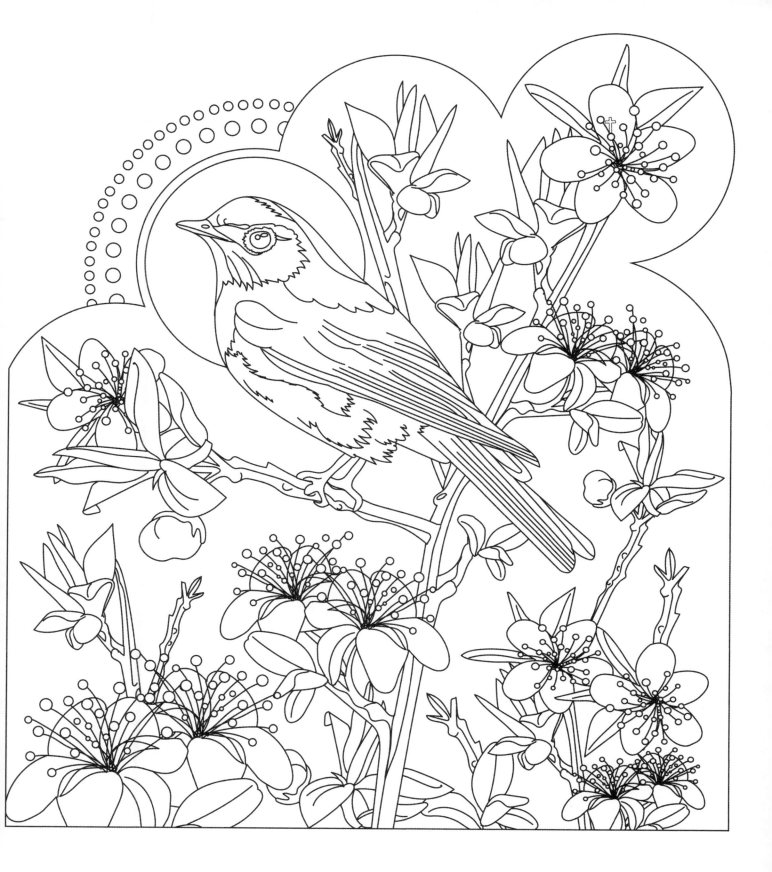

Behold the fowls of the air: for they sow not, neither do they reap, nor gather into barns;
yet your heavenly Father feedeth them. Are ye not much better than they?
Matthew 6:26

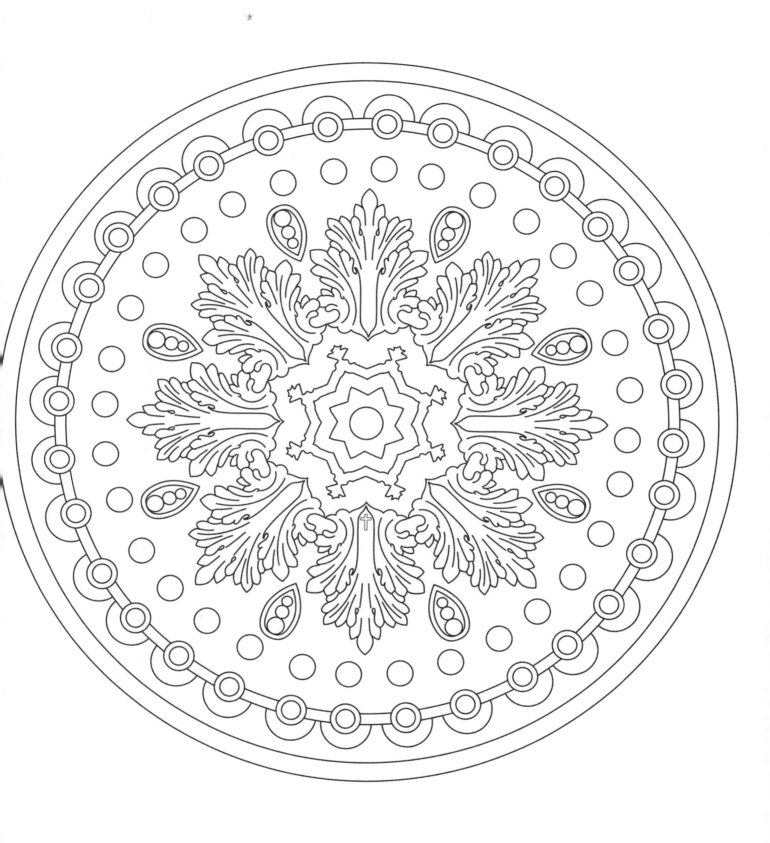

The LORD is merciful and gracious, slow to anger, and plenteous in mercy.
Psalms 103:8

The LORD is good to all: and his tender mercies are over all his works.
Psalms 145:9

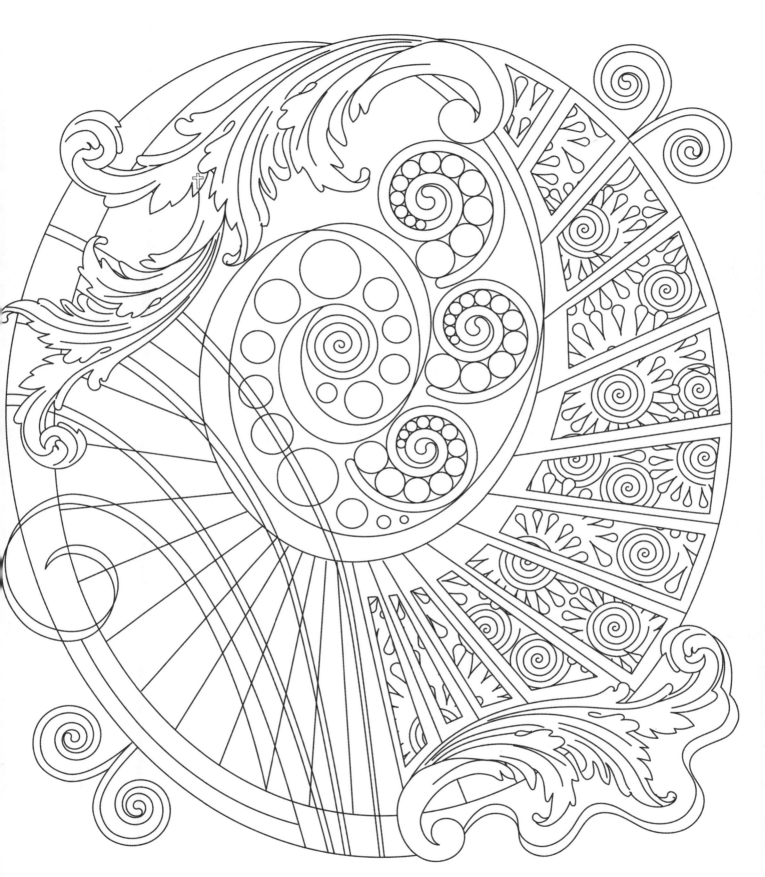

And this is the confidence we have in him, that, if we ask any thing according to his will, he heareth us.
1 John 5:14

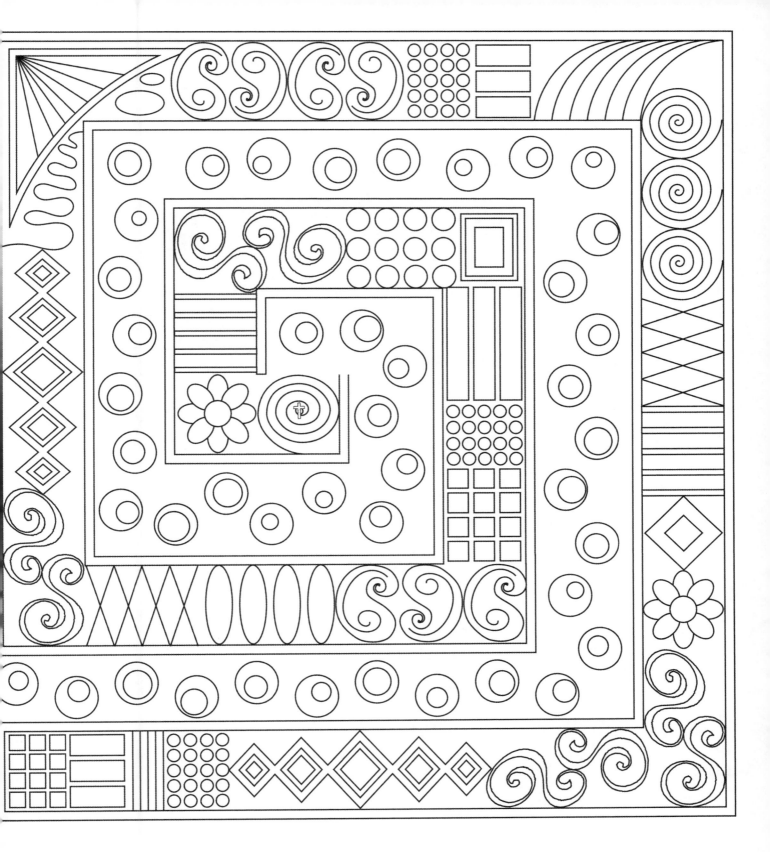

Ask, and it will be given to you; seek, and you wil find; knock,
and it will be opened to you. For everyone who asks receives, and he who seeks finds,
and to him who knocks it will be opened.

Matthew 7:7-8

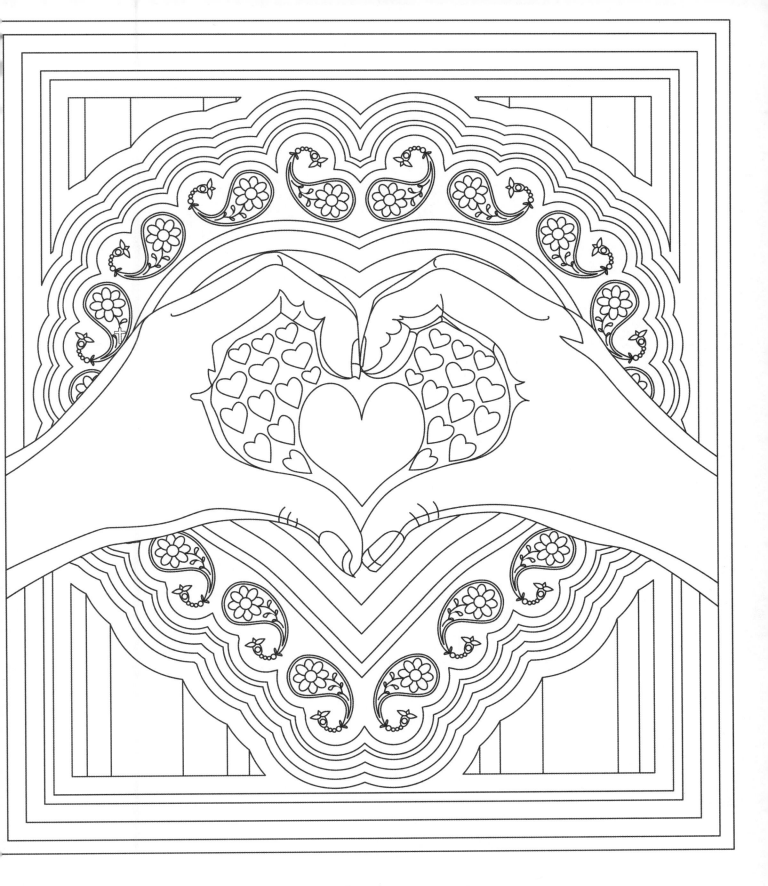

A new commandment I give unto you,
That ye love one another; as I have loved you, that ye also love one another.

John 13:34

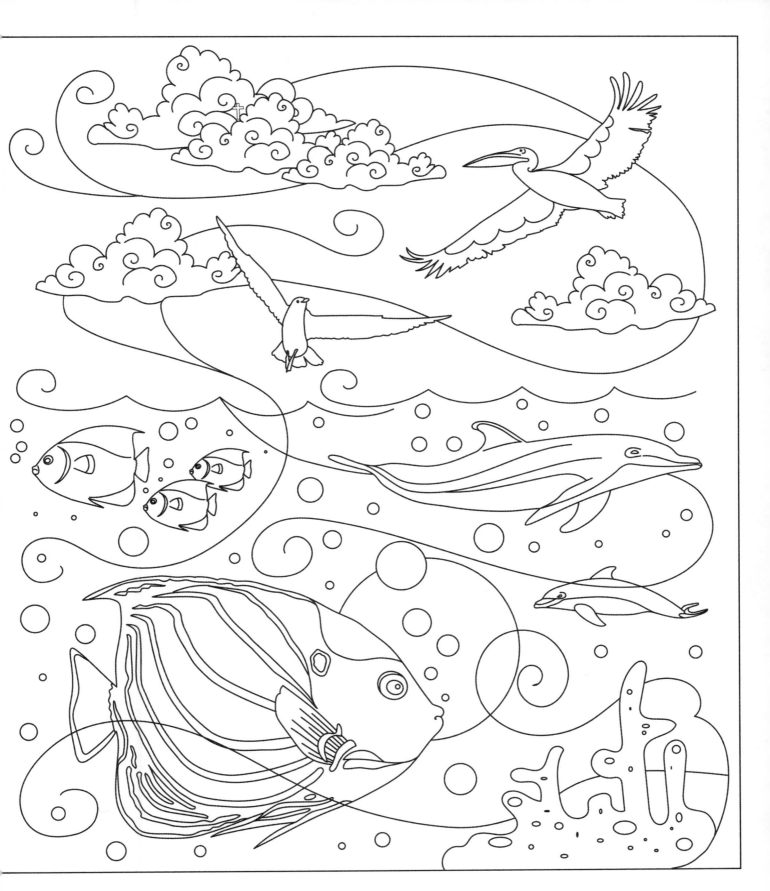

If I take the wings of the morning, and dwell in the uttermost parts of the sea;
Even there shall thy hand lead me, and thy right hand shall hold me.

Psalms 139:9-10

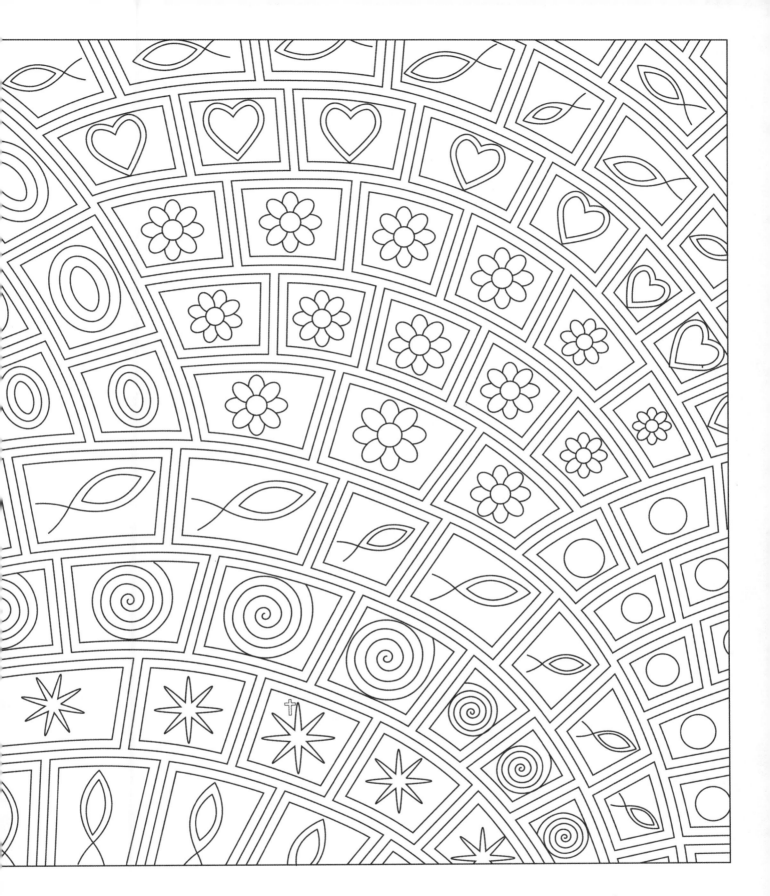

*For I reckon that the sufferings of this present time are not worthy
to be compared with the glory which shall be revealed in us.*

Romans 8:18

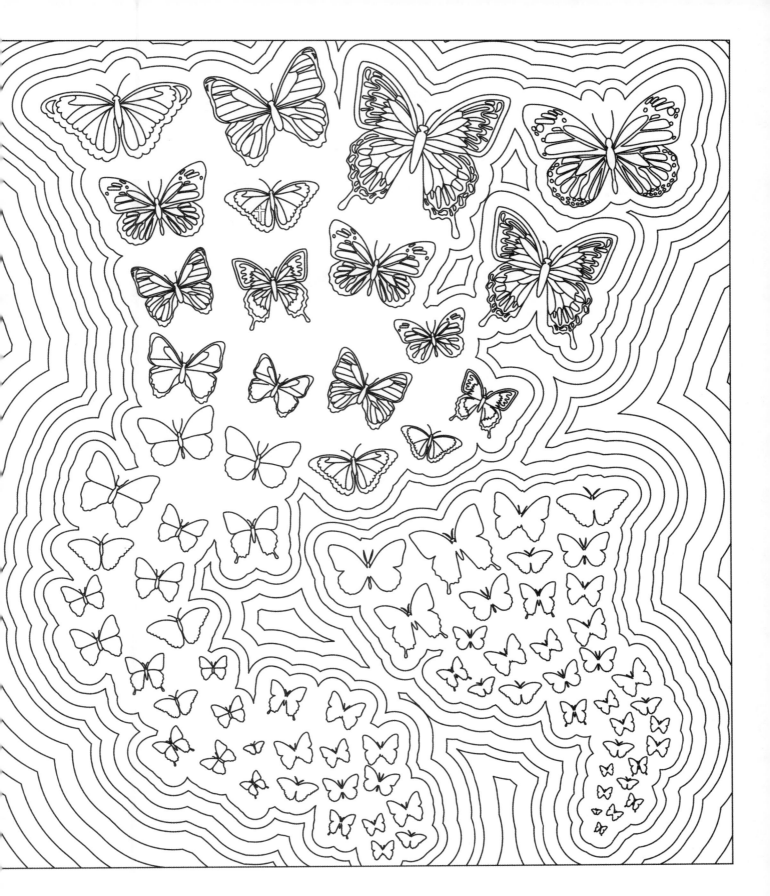

The statutes of the LORD are right, rejoicing the heart:
the commandment of the LORD is pure, enlightening the eyes.
Psalms 19:8

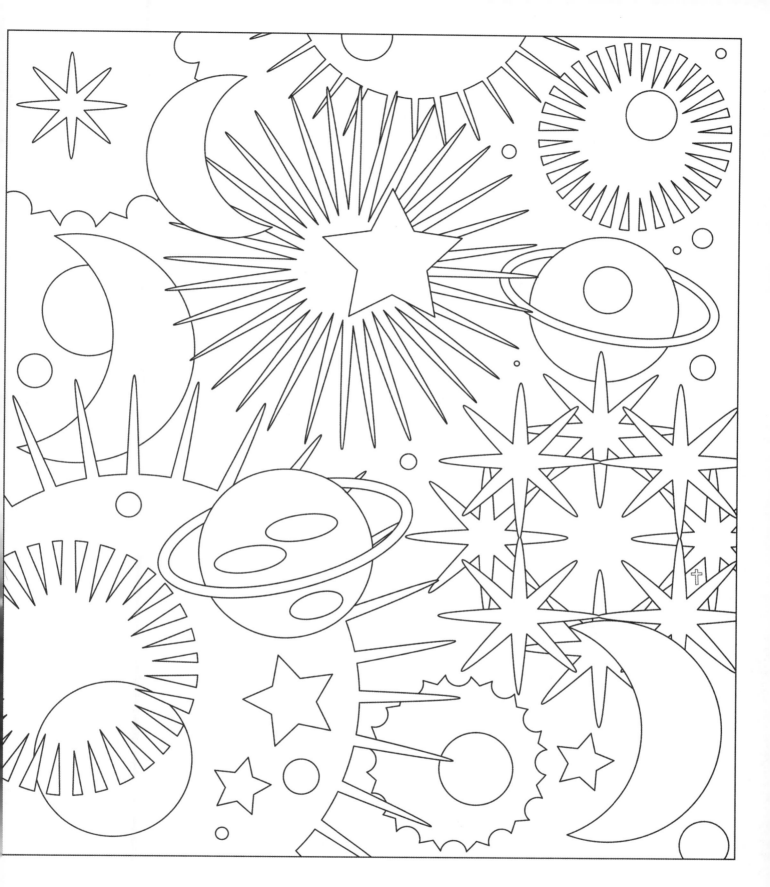

And God made two great lights; the greater light to rule the day,
and the lesser light to rule the night: he made the stars also.
Genesis 1:16

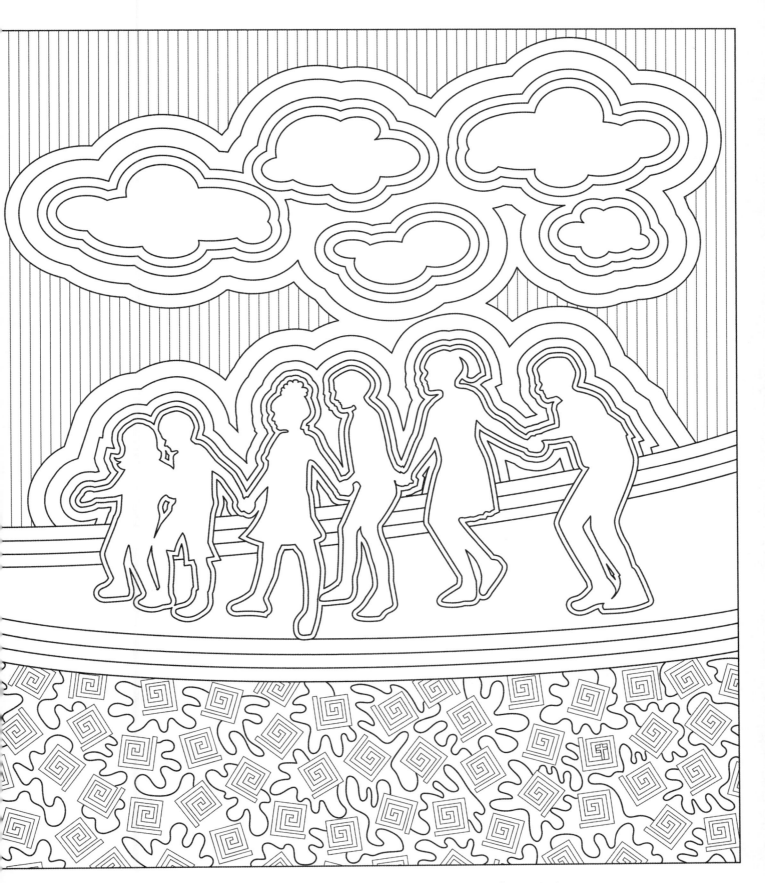

...Suffer the little children to come unto me, and forbid them not: for of such is the kingdom of God.

Mark 10:14

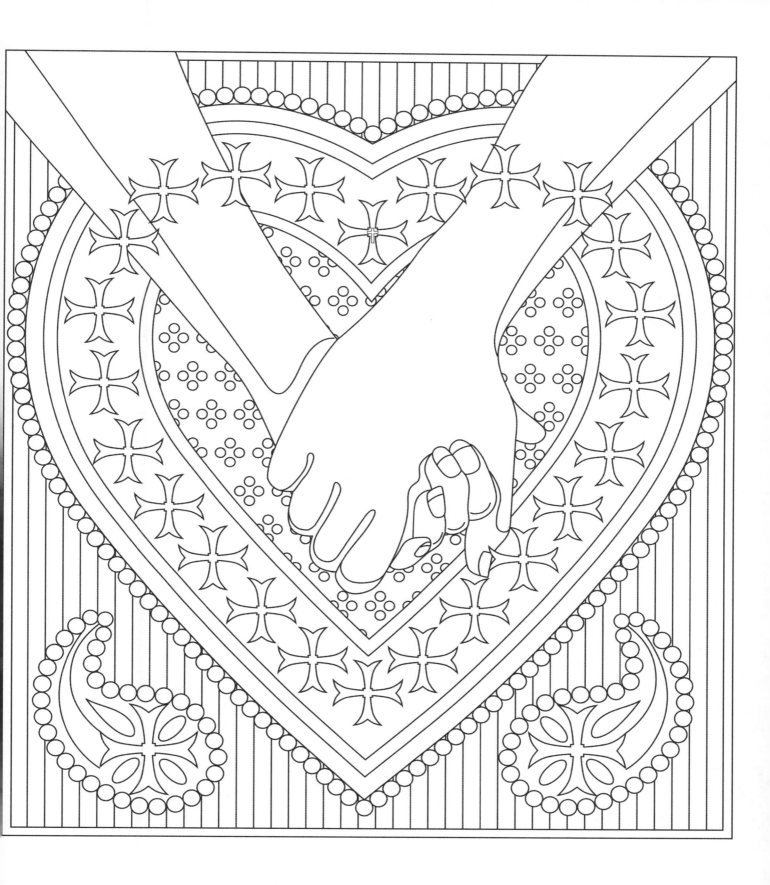

Bear ye one another's burdens, and so fulfill the law of Christ.

Galatians 6:2

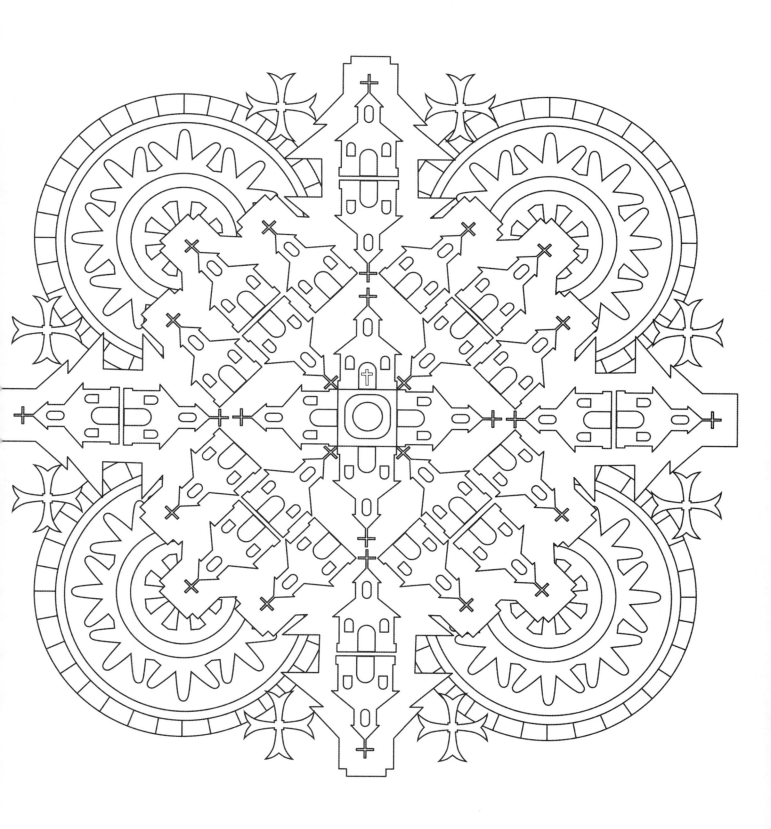

*Thou wilt keep him in perfect peace, whose mind is stayed on thee:
because he trusteth in thee.*

Isaiah 26:3

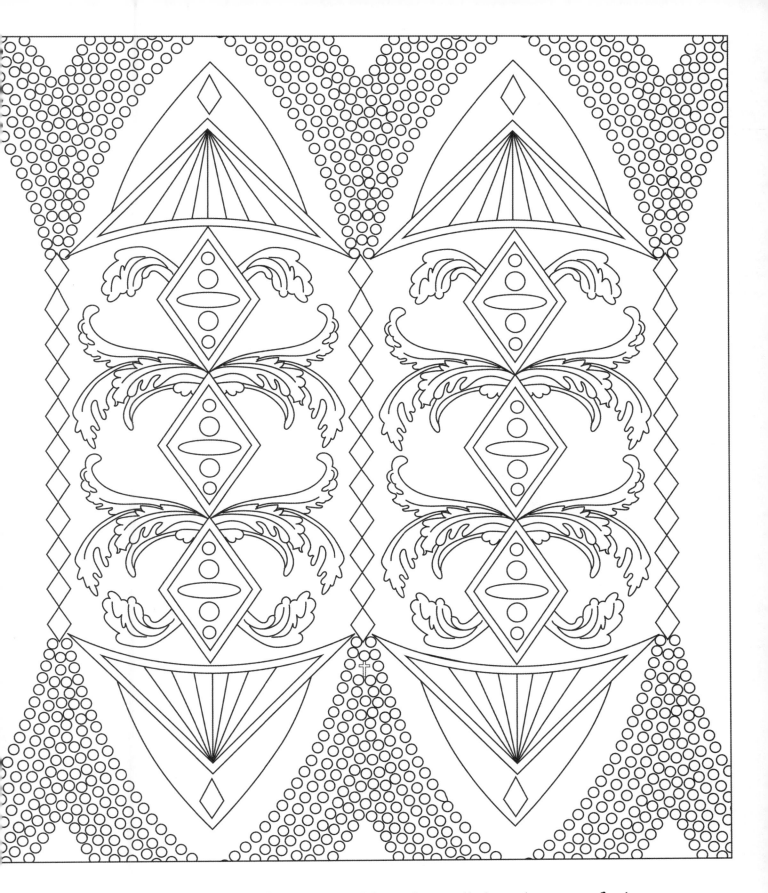

... the LORD is a God of judgment: blessed are all they that wait for him.
Isaiah 30:18

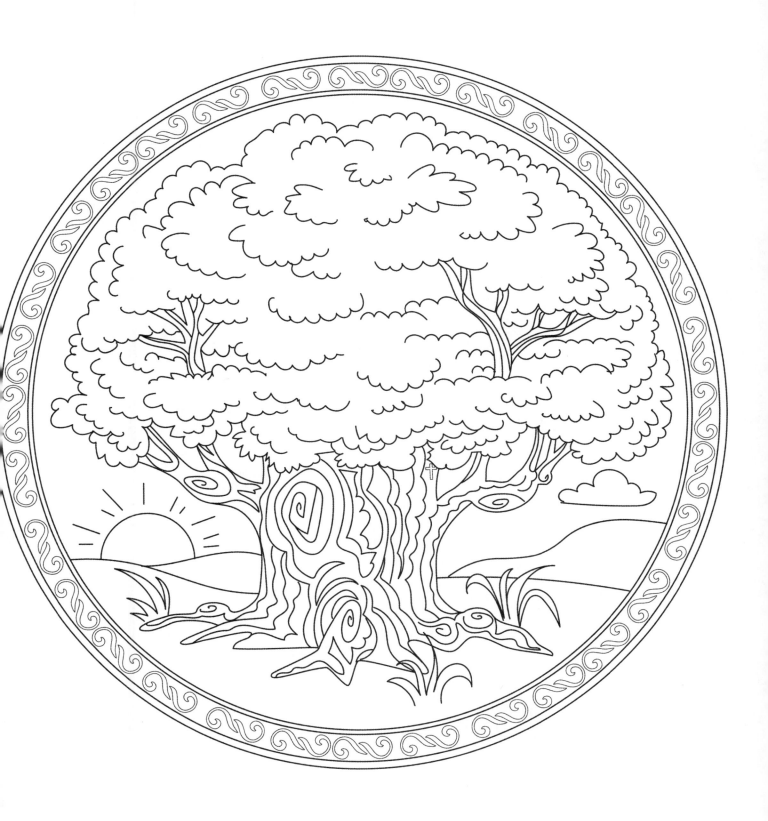

He hath made the earth by his power, he hath established the world by his wisdom, and hath stretched out the heavens by his discretion.

Jeremiah 10:12

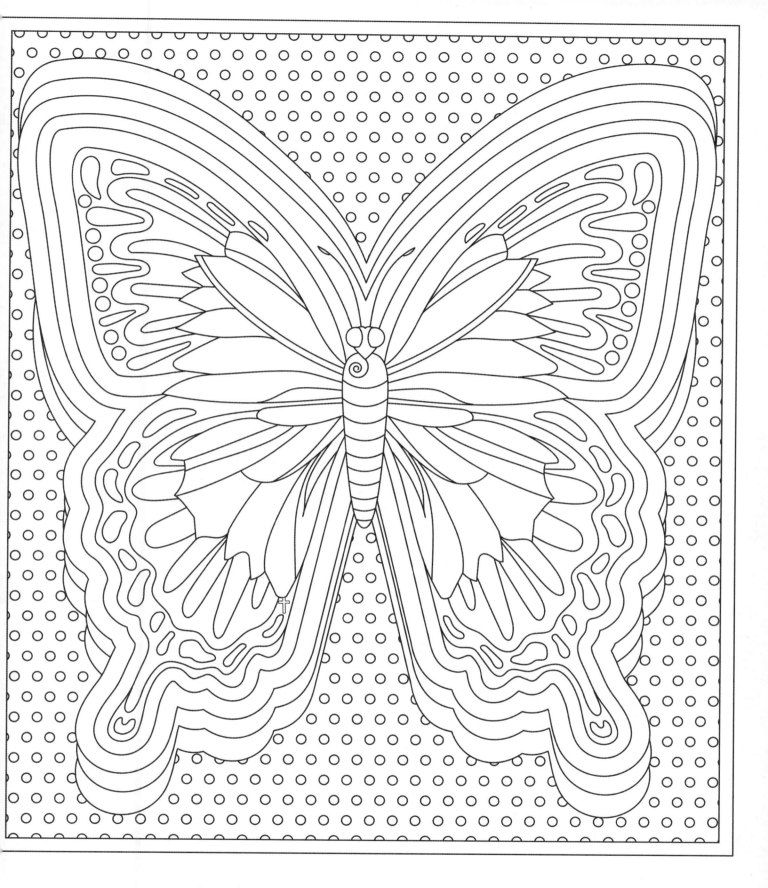

Therefore if any man be in Christ, he is a new creature:
old things are passed away; behold, all things are become new.

2 Corinthians 5:17

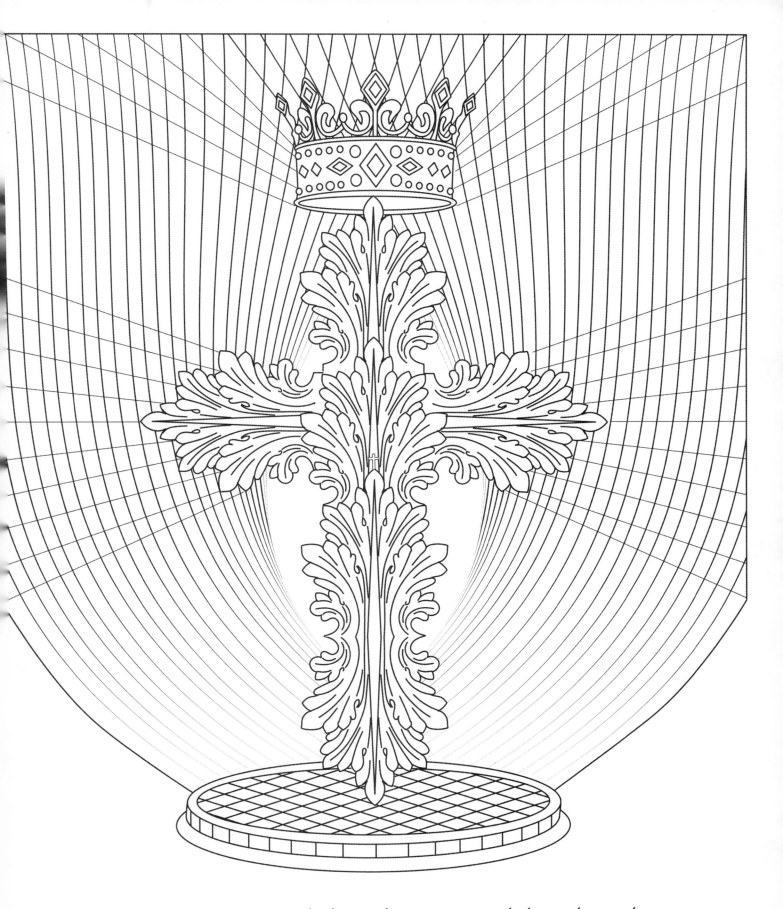

For ye were sometimes darkness, but now are ye light in the Lord:
walk as children of light.
Ephesians 5:8

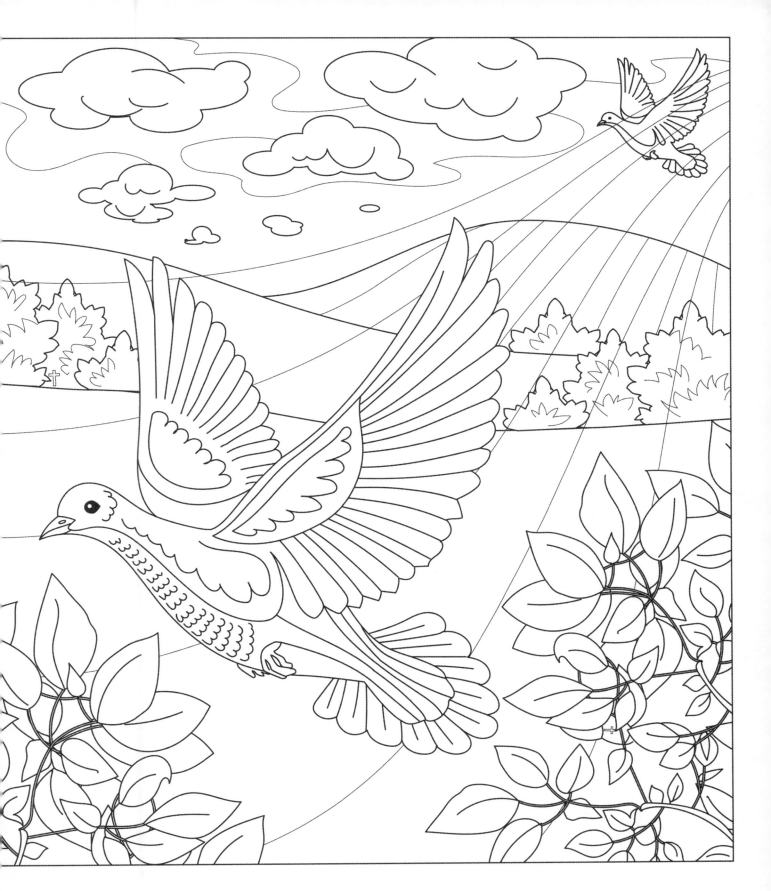

*As far as the east is from the west,
so far hath he removed our transgressions from us.*
Psalms 103:12

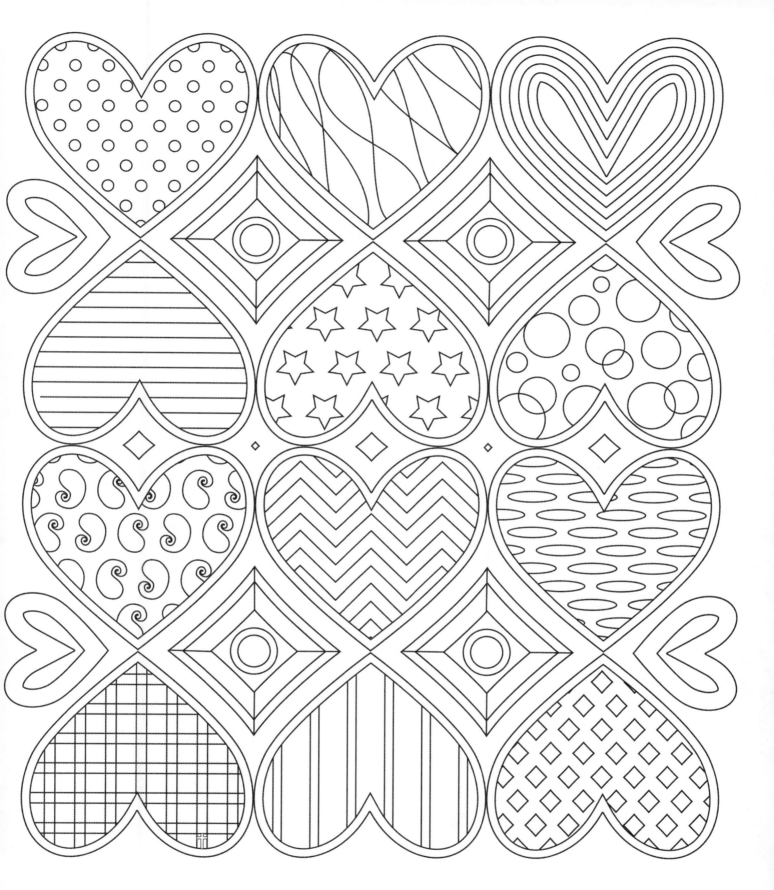

Delight thyself also in the LORD: and he shall give thee the desires of thine heart.
Psalms 37:4

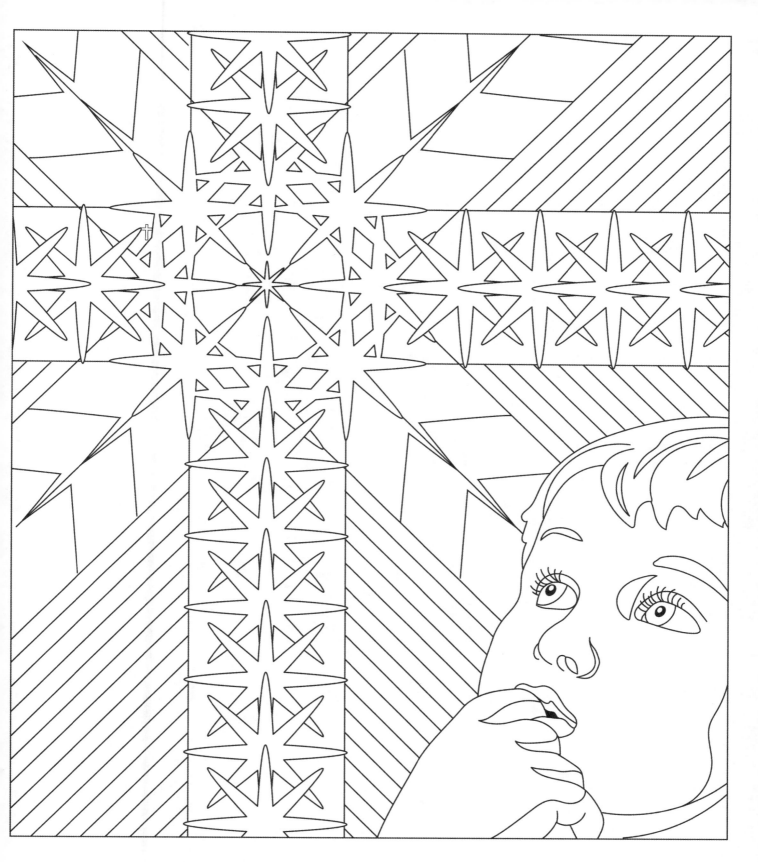

For ye have not received the spirit of bondage again to fear;
but ye have received the Spirit of adoption, whereby we cry, Abba, Father.
The Spirit itself beareth witness with our spirit, that we are the children of God...
Romans 8:15-16

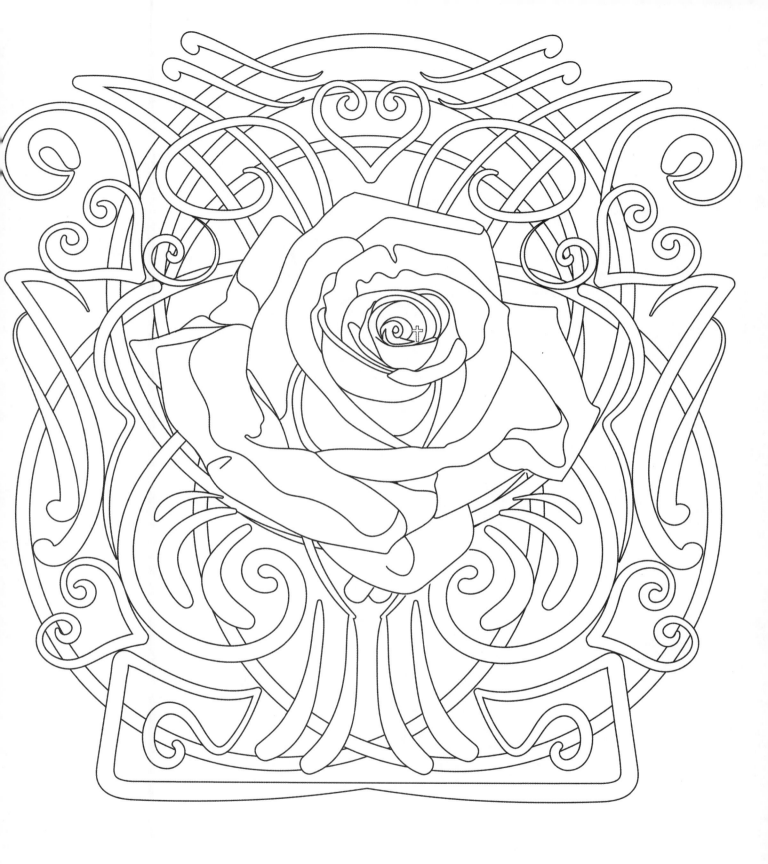

The LORD hath appeared of old unto me, saying, Yea, I have loved thee with an everlasting love: therefore with lovingkindness have I drawn thee.

Jeremiah 31:3

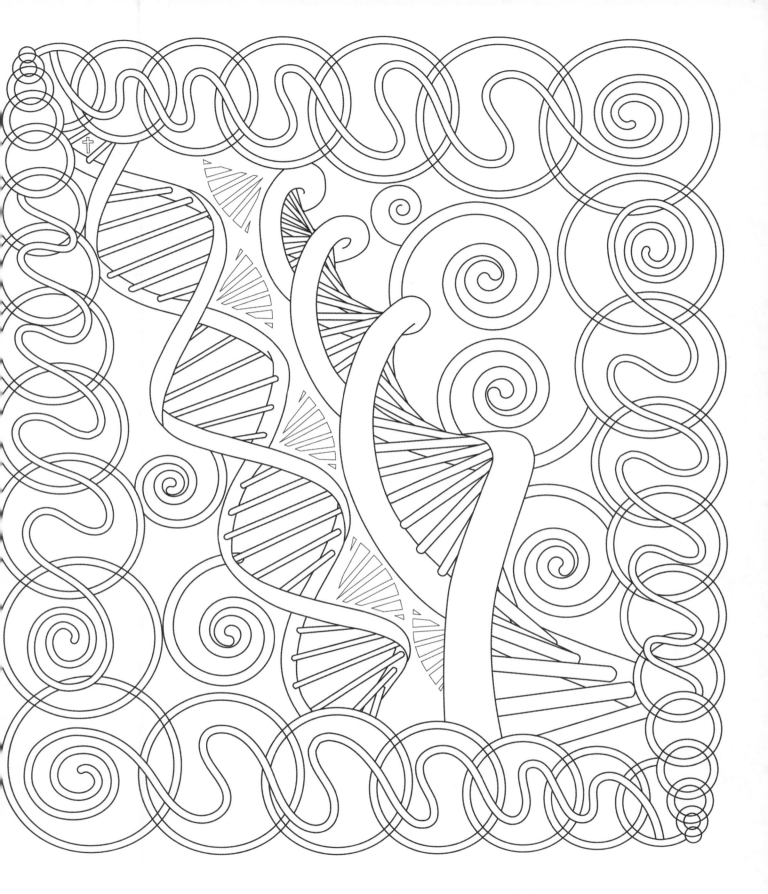

I will praise thee; for I am fearfully and wonderfully made...
Psalms 139:14

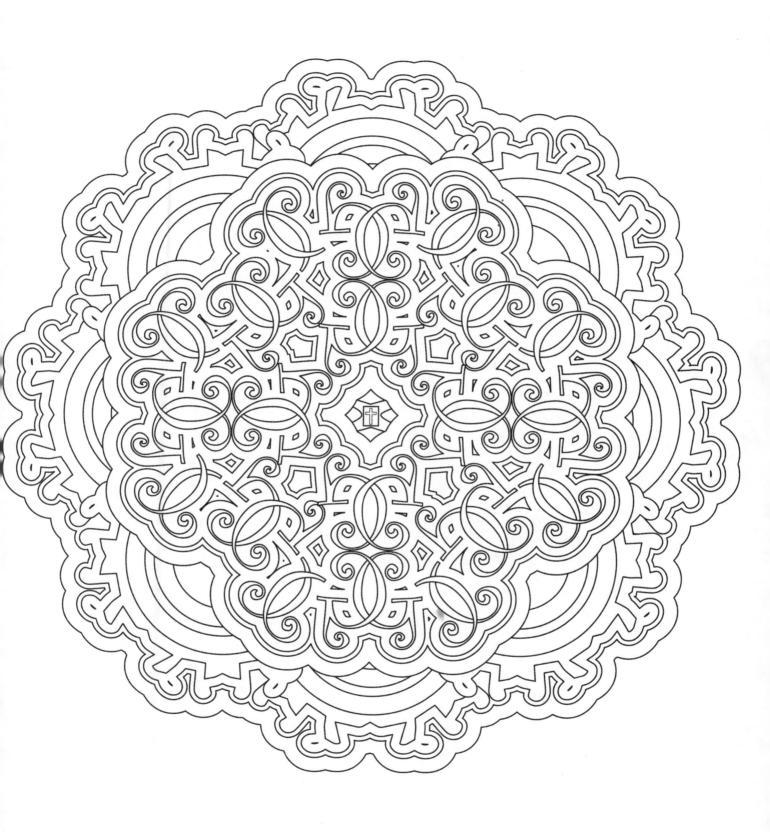

... God is love.
1 John 4:8